# PROVINCETOWN, 1949–1965

*A Photographic Memoir by Jules Aarons*

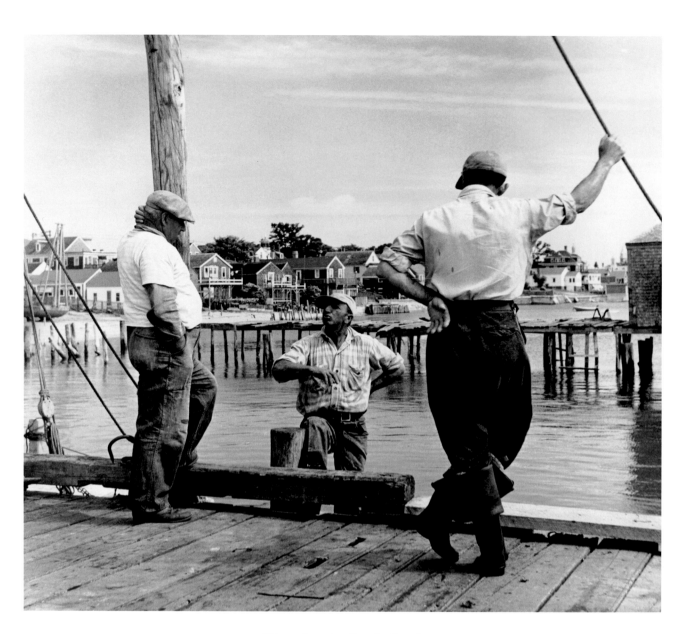

*Discussing the Day's Catch*

# PROVINCETOWN, 1949–1965

## *A Photographic Memoir by Jules Aarons*

*Introduction by* Bernard Margolis

*Essay on Provincetown by* John Stomberg

*Essay on Jules Aarons by* Aaron Schmidt

*Reminiscence by* Jules Aarons

BOSTON PUBLIC LIBRARY

SEPTEMBER · 2002

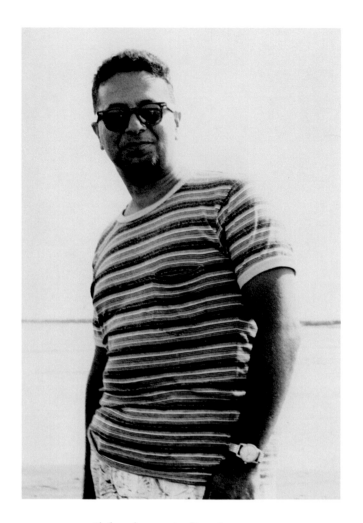

*Jules Aarons in Provincetown*

FRONT COVER: *Joseph Kaplan Sketching on the Waterfront*
BACK COVER: *Art Lovers*

Exhibition held in the Wiggin Gallery, Boston Public Library, in the Fall of 2002

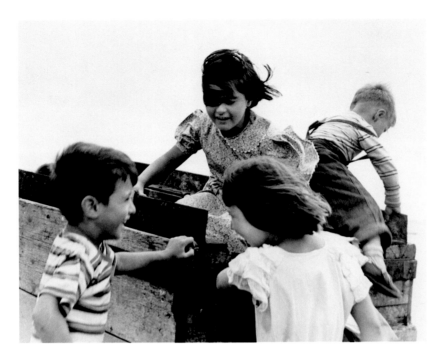

*Kids Playing on the Wharf, After the Catch Is In*

# INTRODUCTION

IN OCTOBER OF 1999, the Boston Public Library held an exhibition and published a catalogue, entitled, *Into the Streets, 1947–1976, Photographs of Boston by Jules Aarons*. It was Jules Aarons' first one-man show in over ten years, and reacquainted Boston with an important and extraordinary Boston photographer; it was, in addition, a celebration of the formation of the Print Department's Jules Aarons Collection. The Jules Aarons Collection is the largest collection of the work of the photographer in a public institution, and a cornerstone of the Library's photographic collections. It is rare that a photographer's work combines so gracefully the vision of the artist and fidelity to the subject. It is fitting that the quality of Jules Aarons' photographs as both document and art reflect the commitment of the Boston Public Library to the community, and

the many ways that we, as an institution, serve that community.

With *Provincetown, 1949–1965, A Photographic Memoir*, we have the opportunity to present Jules Aarons' stunning photographs taken during his time in Provincetown, but also to document a town that holds an important place in the history of art in America. This publication celebrates the photographer's gift of sixty-one photographs by him, from Provincetown summers. It is a symbol of the Boston Public Library's commitment to preserving the historical record of the arts and to our continuing efforts to build our collections of original work by the artists of Boston.

BERNARD A. MARGOLIS
*President, Boston Public Library*

5

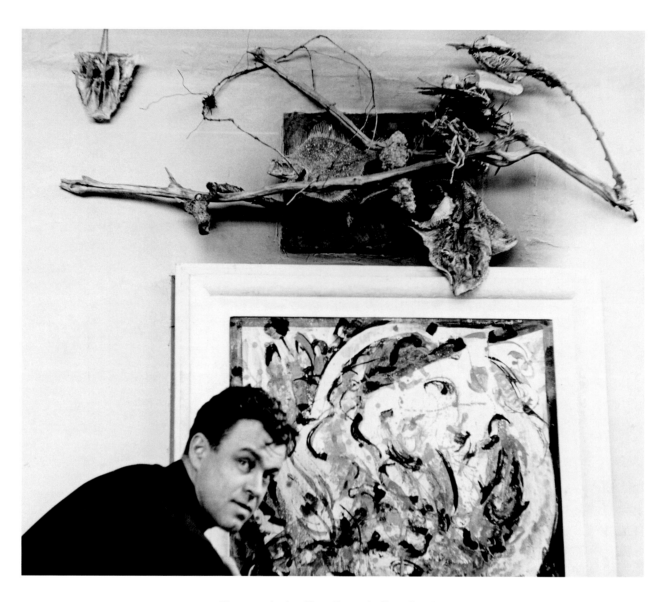

*Boston Artist Ken Campbell in Studio*

# PROVINCETOWN–1949

*A man may stand there and put all America behind him.*

Henry David Thoreau describing Provincetown in *Cape Cod*

(1864)

1949. IT WAS ONE of those summers in Provincetown—a season that came to define the time and the town as we know it. There had been others, no doubt. Some of the watershed dates in the town's evolution were scarcely noticed at the time, while others brought about tremendous transformations seemingly overnight. 1949 was one of the latter. Those who were there would recall the summer's events in great detail for the remainder of their lives. Though the town had by then long enjoyed dual status as a fishing village and an artists' colony, that year the balance shifted demonstrably and permanently toward the cultural.

The photographer Jules Aarons spent his first summer in Provincetown that year.[1] He realized that the strong dynamic of the contrasting cultures defining the town—the fishing village and the artist colony—formed the essence of the place. His photographs from that summer preserve both Provincetowns, recording the workings of the arts and the fishing communities. The two had long coexisted, at times more happily than at others. The summer of 1949 was particularly active because of Forum 49—a series of lectures, debates, poetry readings and performances. These events, coupled with myriad exhibitions and social gatherings, garnered newspaper coverage from Boston to New York. With all the attention, Provincetown was discovered once again, leading to a further increase in the level of summer activity in the years that followed. This discovery—some say invasion—repeated a pattern

long established in the history of the Outer Cape.

Provincetown's history is characterized by many such discoveries. Key to understanding the Outer Cape's cultural legacy is the evolution of transportation. When Henry Thoreau visited, on successive trips between 1849 and 1855, he arrived by ship and walked great distances.[2] He understood the special potential of a place where one could put the entire continent behind him and begin afresh—he knew too that "the time must come when this coast will be a place of resort for those new-Englanders who really wish to visit the sea-side." In the meantime, he predicted, the difficulty of access assured the town's protection from those tourists who "think more of the wine than the brine."[3]

The completion of the rail line that had been slowly progressing down the Cape throughout the 19th century offered the next step in the rapid conquest of the space between Provincetown and the rest of the country.[4] In 1873 the train began bringing throngs of visitors to the end of the Cape. Ironically perhaps, Thoreau's book became a guide of sorts to the railroading set, fueling enthusiasm for the trip to the remote fishing village at the end of Cape Cod—this was particularly true for travelers coming through Boston.[5]

By the turn of the century, the Fall River Steamship Line had become the popular mode of travel for New Yorkers. Formed from the merger of a railroad company and a steamship line, the outfit offered service aboard a steamship from New York City to Fall River where the passengers

boarded a train that would bring them to Provincetown. For the passengers the journey was relatively painless, with the overnight passage up Long Island Sound made pleasant on a luxurious side-paddle ferry and all connections assisted by company porters.[6]

In 1899, when Charles Hawthorne established his Cape Cod School of Art, one key aspect of the school's popularity was its accessible remoteness made possible by the train. This school's contributions to village life began humbly with a small number of students working in Hawthorne's atelier. But the school soon developed into a widely respected enterprise attracting hundreds of eager students each season. Its classes eventually approached the level of spectacle on the days when Hawthorne held his demonstrations on the public wharfs.

The events of 1914 in Europe brought a group of dedicated expatriate artists and writers back to the United States and many of these ended up in Provincetown. With the establishment of the Provincetown Players even more of New York's Greenwich Village bohemia transplanted itself to the Outer Cape that season.[7] Throughout World War I, the town was a place of notorious, sometimes spectacular, events that included artists, critics, political activists, and assorted other scene-makers—particularly Greenwich Village bohemians—all transplanted miraculously on the overnight ferry from New York's North River terminal.

By establishing a summer school in Provincetown during the summer of 1934, Hans Hofmann further cemented the connection to New York.[8] Arguably the best known of all the town's art schools, Hofmann's was a direct extension of the classes he taught at a studio in Greenwich Village and included many of the same students. His summer activities drew these students, as well as their friends and others, to the Cape. According

to Mary Drach McInnes, "The popularity of the Hans Hofmann School of Fine Art . . . grew appreciably after World War II due largely to the funding of the G.I. Bill." As well, she notes, the school's "enrollment changed from an intimate avant-garde group to a large, diverse student body from across the United States."[9] In his courses, artists from many different backgrounds mixed, but the New York axis dominated. Hofmann's presence established the toehold on Provincetown for various Abstract Expressionists, including Adolph Gottlieb and Robert Motherwell, who took to summering at Provincetown—especially in 1949 and thereafter.

As Dorothy Gees Seckler, author of a distinctive study of Provincetown painters, writes about the critical summer of 1949, "Many New York vanguard painters were in and out of town along with a California contingent and, of course, the Abstract Expressionists. The new art currents that had seemed diffused only a season or so before were now being defined and elaborated not only to other artists but also to a newly arrived throng of admiring bystanders in animated gatherings in studios, cafes and on beaches."[10] The Abstract Expressionists were just beginning to gain recognition and their approach to painting still caused passionate response from those involved in the arts.[11] Their increasing association with Provincetown undoubtedly added greatly to the town's visibility as a major cultural center at mid-century.

At the heart of the summer was Forum 49. In a series of lectures and events, as well as in the gallery, the new art tendencies were debated, defined, and exhibited.[12] The lecture series sold out each week, with many people standing throughout the presentations in order to hear the thoughts of those responsible for changing so dramatically the look of American art. Don Witherstine, proprietor of the Shore Studios Gallery

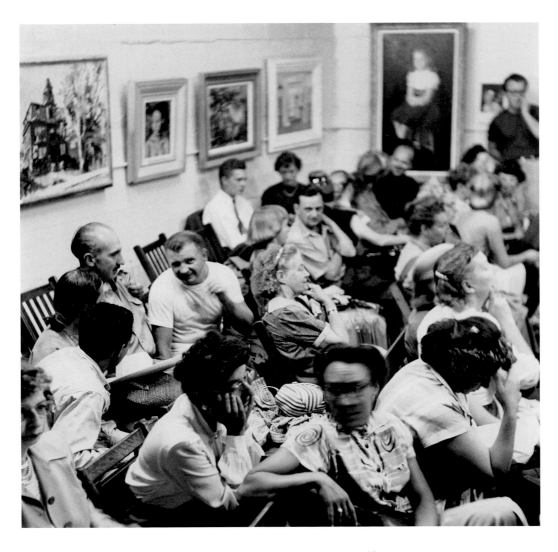

*Audience for Lecture, Forum 49*

in the West End of town, allowed his new Gallery 200 (located at 200 Commercial Street) to be used for the Forum Sessions. The organizers were two poets, Cecil Hemley and Weldon Kees. Hemley enticed his cousin Adolph Gottlieb to join George Biddle, Hans Hoffman, and Serge Chermayeff for the season-opening debate, "What is an Artist?" Despite having room for over 200 people, they still turned away more than twice that many interested visitors. From the first night on through the next two months, the weekly sessions drew large audiences and national attention in the press. Largely due to Forum 49, with its attendant crowds and publicity, Seckler portrays 1949 as "a milestone summer for Provincetown."[13]

These are the escapades captured in Aarons' photographs of that season. Aarons knew Cecil Hemley, whose poetry he admired, and he was friends with several of the Boston artists. Many of these would drive down to the Outer Cape— sometimes just for the weekend—in order to attend Friday night openings or other weekend classes, parties, and events such as the Forum 49 series. There has always been a strong contingent

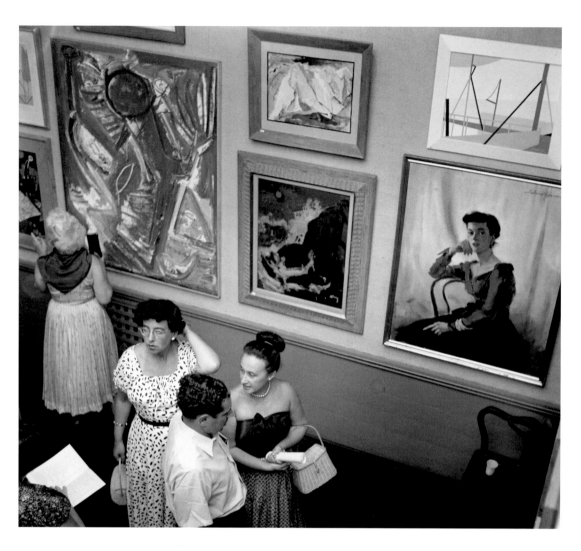

*Provincetown Art Association Opening*

of Bostonians who have figured prominently into the fabric of Outer Cape life. Mostly less well known than the New Yorkers, these individuals enjoyed the vibrant offerings of both the cultural scene and the potential for solitude that the Outer Cape offered. According to the painter Kahlil Gibran, the school Kenneth Campbell operated at 5 Brewster Street, the Studio 5, was a center for many of the Boston area painters.[14] Campbell's school featured both painting and dance, reflecting the post-war trend among many in vanguard art circles to merge the two.

The Bostonians had the advantage of driving to the Cape—a mode of transport that increased greatly as the highways were improved in the decades following World War I. From a dirt road plagued by shifting sands, to the easily traveled Route 6A of post-World-War-II renown, the automobile option itself spurred further increases in the burgeoning summer life of the town and provides one of the keys to understanding the transition of 1949.

Ruth and Lawrence Kupferman, central figures in the Boston contingent to Provincetown

in the years leading up to and including 1949, stopped going after that key summer.[15] Ruth Kupferman insists that it was not just the changes that followed the notoriety of that summer. Though the influx of tourists that intensified beginning in 1950 was a huge factor, her husband, along with Mervin Jules, was asked to teach at a new summer program being established in Falmouth Heights. After 1950, they preferred the relative quiet of "upcape" to the pandemonium that Provincetown life was evolving into during the summers.

Aarons too recalls how cheap a stay in Provincetown remained through the late 1940s and how rapidly it was changing. In 1949, artists were still able to swap drawings for fish or just receive them gratis. He recalls waiting for the returning trawlers at the pier. He often received the benefit of a fisherman's generosity, receiving the gift of a weekend's worth of fish. As he remembers it, there was little discord between the two communities. One small group of fishermen actually donated fish weekly to the painters involved with Campbell's Studio 5.[16] The art community itself endured a seemingly endless series of internal imbroglios, but for the most part they all felt welcomed in the town despite the massive influx of visitors.

Gibran likes to relate a telling anecdote about the changes affecting Provincetown life in those days. He spent a day on the backside or ocean-side beach with fellow Boston painter Hyman Bloom sometime during the summer of 1949. After hours alone, they spotted a lone swimmer making his way to the water about a half-mile away down the beach. At this sighting, Bloom commented, "Provincetown is getting way too crowded."[17] Though comical, Bloom's observation captures that sense that change again loomed in the immediate future. By the 1950s, a mid-summer day alone on the ocean-side beaches

became the stuff of memories. Coupled with the positive press that the activities of that summer received, the vast expansion of the economy, automobile traffic, and the interstate system in the 1950s stripped away the last vestiges of Provincetown's seeming inaccessibility.

Change follows discovery as inevitably as does nostalgia. We all share the tendency to equate discovery with a primal state; the moment we gain knowledge of a place we start our memory clock. Of course, change occurs after the establishment of our benchmark. Provincetown has always been in flux, but the summer of 1949, the summer of Jules Aarons' discovery, was the moment that Provincetown became personal history for a whole new generation of visitors. Despite our awareness of how individuals construct nostalgia, that summer did coincide with a major transition for both the artists who visited and for the local communities. By virtue of having been discovered, again, and the press that followed, demand for the limited resources of the tiny town were further stretched during the summer. It became increasingly hard for artists to afford the summer's rent in town. Following the lead of Edward Hopper and Ben Shahn, who had for decades chosen nearby Truro, many artists began to spend their summers in that neighboring town and others, such as Edwin Dickinson, drifted even further to Wellfleet.

Parallel to the exponential growth of the cultural, seasonal community, the year-round residential population that had grown steadily since the 17th century leveled off at just over 4,000 around the turn of the century.[18] It remained uncommon for the writers and painters who flocked to Commercial Street in July to winter there. The year-rounders in Provincetown were largely of Portuguese descent and made their living off the sea. As in the artists' groups, there were internal struggles within these populations.

The Anglo occupation began with the pilgrims who left Plymouth in search of better land. That group knew of Provincetown as they had landed there first before moving on across the bay. By the late 17th century, though, significant numbers of Portuguese sailors made Provincetown their home as well and they were not always welcomed as additions to the small community.[19] Though the Portuguese population was strong in many port cities along New England's coast, Provincetown enjoyed a disproportionately large community.

In Aarons' work over the summer of 1949, and on successive trips in the early 1950s, he visited both Provincetowns. His pictures relay the bifurcated nature of life in the Outer Cape. It was a place where the ancient and essential task of food-gathering mixed with vanguard cultural activities in the heated atmosphere of a place that felt like the end of the world—a place apart. The characterization of Thoreau, that, "A man may stand there and put all America behind him," reflects well the essence of Provincetown. It was a place to put the expectations and constrictions of the rest of the country behind you and to focus on unfettered possibilities. A place of "what if?" That was the spark of place that Aarons examines with his photographs: the enduring tradition of the fishing community and the restless experimentation of the cultural entrepreneurs populating the last town in America.

JOHN STOMBERG
*Associate Director for Administration and Programming*
*Williams College Museum of Art*

12

## NOTES

1. Information from Jules Aarons for this essay was derived from an interview held at the Boston Public Library on 7 February 2002. Participating were Sinclair Hitchings, Kahlil Gibran, Ruth Kupferman, Jules Aarons, Aaron Schmidt and myself. Hereafter referred to as: BPL interview.

2. Joseph J. Moldenhauer, "Historical Introduction," in Henry D. Thoreau, *Cape Cod*, Joseph J. Moldenhauer, ed. (Princeton, NJ: Princeton University Press, 1988), 249.

3. Thoreau, *Cape Cod*, 214.

4. Paul Schneider, *The Enduring Shore: A History of Cape Cod, Martha's Vineyard, and Nantucket* (New York: Henry Holt and Company, 2000), 308.

5. Leona Rust Egan, *Provincetown as a Stage: Provincetown, The Provincetown Players, and the Discovery of Eugene O'Neill* (Orleans, MA: Parnassus Imprints, 1994), 80–81. For much of the factual information in the present I have relied on Egan's excellent overview of the development of the Cape's transportation system and its impact on the events in Provincetown.

6. Dorothy Gees Seckler, "History of the Provincetown Art Colony," in Ronald A. Kuchta ed. *Provincetown Painters* (Syracuse, NY: Everson Museum of Art, 1977), 19–25.

7. Seckler, 33.

8. Seckler, 59.

9. Mary Drach McInnes, *Provincetown Prospects: The Work of Hans Hofmann and His Students* (Boston: Boston University Art Gallery, 1994), 6.

10. Seckler, 64.

11. As an example of the continuing ambivalence toward Abstract Expressionism in 1949, Kahlil Gibran notes that paintings by Jackson Pollock and Willem DeKooning were selling for $500, but his own paintings sold for $600. BPL interview.

12. My account of Forum 49 is based mostly on the account of Seckler, but verified by Gibran, Kupferman, and Aarons, who were often in attendance that summer. See Seckler, 64–67.

13. Seckler, 64.

14. Kahlil Gibran, BPL interview. Gibran, nephew of the author of the same name, spent the summers of 1949–1952 working and painting at Provincetown.

15. The Kupferman's spent the summers of 1946–1949 at Provincetown. Ruth Kupferman, BPL interview.

16. Kahlil Gibran, BPL interview.

17. BPL interview.

18. Egan, *Provincetown as Stage*, 91. Egan explains that the Portuguese sailors came largely from the Azores and ended up in Provincetown for a variety of reasons. Local captains actively recruited some of these sailors as their skills were widely acknowledged and respected; others simply abandoned the ships on which they had been working upon arrival in town because the abundance of fish locally offered the promise of a better life.

19. Schneider, *The Enduring Shore*, 227.

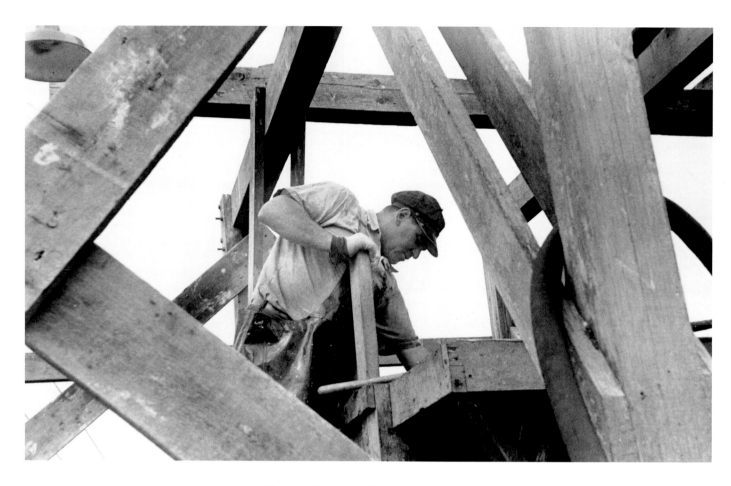

*Getting Ready to Process the Catch*

# JULES AARONS IN PROVINCETOWN

IN 1949, HIS FIRST SUMMER in Province-town, the Boston photographer Jules Aarons and his family stayed in a small one-room cottage adjacent to the larger house that his friends, the artists Lawrence Kupferman and his wife, Ruth Cobb, had rented.[1] Personally for Jules a happy arrangement but one that also mirrored the relationship of photography at that time to the larger world of art. This was a crucial period in the history of American art but photography was at best a peripheral presence.

In Provincetown that summer, painting was the thing. Provincetown in 1949 was an artistic Tower of Babel with artists in different media mingling and talking, listening and arguing. But the stars of the show were the painters. Photographers were welcome in Provincetown, they weren't turned away at the town line and sent back to Hyannis, but they weren't a big part of the conversation. So Jules in Provincetown was more of a spectator than a participant. But that was ok. As a photographer, that was what he did best. He may not have been talked about but he did listen. And he took photographs.

Jules Aarons had been working seriously as a photographer for two years when he first arrived in Provincetown. He was an amateur in the best sense of the word. He was self-taught but serious and approached photography with rigor and purpose; his photographs were expressions of his vision of the world. He had taught himself to print and developed a style of printing that fit his approach to his subject matter. From the beginning his focus was on people and he developed a "hard" printing style with neutral tones that he used to undercut his sympathetic view of his subjects.[2] He had also educated himself in the history of photography, giving him an understanding of the different ways people had been photographed, from 19th century portraiture to the candid work of the street photographers and his hero, Henri Cartier-Bresson. For Jules, photography was not a hobby. He was working hard to establish himself as an engineer and a scientist in his work for the Air Force but he was working just as hard to establish himself as an artist.

Having a day job did not make Jules an exception in Provincetown. Many of the artists, especially the younger ones, had to work during the summer in restaurants, shops and on the docks in order to afford even the then minimal expense of living and working in Provincetown.[3] Jules was different and his story unique because he had no intention of devoting himself entirely to photography. From 1947 to 1981, when he stopped photographing, Jules' careers ran on two parallel tracks. He was committed to both. In a time of increasing specialization in education and industry, Jules had no problem considering himself both a scientist and an artist. In photography, Jules had met his medium.

It was in Provincetown that Jules received his first and only instruction in photography through a relatively brief series of critiques by Sid Grossman.[4] Completely self-taught and educated to that point, Grossman's often caustic comments helped Jules clarify his approach to photography. The experience helped Jules develop his style of juxtaposing human figures against their dramatic and often abstracted surroundings. Grossman's

teachings sharpened Jules' critical judgment in the printing and, more significantly, composition of his photographs.

One thing Jules had, something that can't really be taught, was timing: knowing, sensing the exact second to snap the shutter and expose the film. Jules would often take only 3 or 4 exposures over the course of a weekend in Provincetown while he searched for that perfect moment. But the other side of Cartier-Bresson's equation of "the decisive moment," the ability to recognize and compose forms, is a different story. Grossman's critiques helped Jules to concentrate on form in his photographs, what Jules has referred to as "discipline within the frame."[5] This awareness helped Jules to frame his subjects in near abstract backgrounds that added drama and complexity to his photographs. During the time of his contact with Jules, Sid Grossman was, in turn, instructed by the painter and teacher Hans Hofmann, and Grossman discussed Hofmann's theories with Jules and his other students. It is likely that Hofmann's emphasis on recognizing and using form from nature reached Jules through the lens of Grossman's critiques. In describing his work Jules states that the photographer "can . . . deal as an artist does with portions of his painting . . . he completes his contribution in printing, pushing some portions of the photo into prominence and pulling other portions into the background,"[6] phrasing that echoes Hofmann's terminology in describing the relationship of forms in painting.[7] It would be hard to find two artists as radically dissimilar as Hans Hofmann and Jules Aarons, and hard to believe that the teachings of the exuberant colorist and midwife of Abstract Expressionism could influence the Boston street photographer's black and white photographs, but that was just the kind of magic that was happening in Provincetown that summer.

In Provincetown in 1949, Jules was a bystander, an observer. But the camera gives the observer the power to construct the scene, to record it and to create a permanent memory. The photographs that Jules took while in Provincetown are very like the photographs he took in Boston and that he would continue to take throughout his career in cities and streets throughout the world; but to anyone who has been there, they are unmistakably P-town. Jules never leaves the people in his photographs floating in an empty frame. They are placed securely in their environment, in places where they are comfortable and where they belong. In Provincetown Jules concentrated on the two communities that existed side by side in the summer: the fishing village and the artist colony. Both communities were engaged in the pursuit of an elusive catch and Jules set out to document their work.

He went out several times with fishing crews and photographed men immersed in their work, completely unconcerned or unaware of the presence of the photographer. His fishermen show the concentrated ease of experienced and skillful hands doing a hard job. The ocean, piers and sky provide the ideal backdrop to the iconic figures of the fishermen, and the tools of their trade, nets, ropes and dories, give the photographer forms and textures to work into the frame. Jules used a Rolleiflex twin-lens reflex camera in a 2¼ format throughout most of his career and it was the perfect instrument. The larger medium-format negative gave him more control of the details in printing the photograph but the camera was small enough to mask his intentions. The Rolleiflex was held at waist level and the photographer could look away from the subject when composing and exposing the photograph, allowing for candid photographs and unselfconscious subjects. The people in Jules' photographs often did not know they were being photographed. His photographs

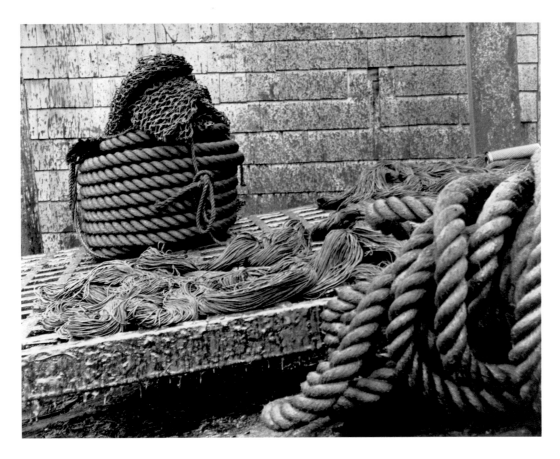

*Coils of Rope.*
*(Aarons occasionally turned his camera away from human activity to photo-*
*graph details of objects and scenes. His unpopulated photographs display his skill*
*in composition and gift for working forms and patterns into his photographs).*

of fishermen in Provincetown show the delicate balance between form and action that he would maintain throughout his career.

Jules had to take a different approach to photographing artists in Provincetown. Artists are self-conscious; it's the nature of the beast. Although the many lectures and openings provided Jules with the opportunity to shoot the artists in their natural habitat, his portraits of artists in Provincetown were conscious collaborations between photographer and subject. Not just aware of the photographer, they brought their own drama to the photograph. Shown with their paintings and sometimes at work either in the studio or outside in the crystal light of the Provincetown summer, in the portraits both the artists and their art are on display.

1950 was the second and the last full summer that Jules would spend in Provincetown. Although he would return frequently throughout the 1950s and into the 1960s, it was for short periods of time, too short to allow him to immerse himself in the scene. Most of his Provincetown photographs were taken in those first two years. Back home in Boston, Jules' pursuit of his photographic career was cloaked in anonymity. At first

this was because of the general lack of public interest in photography early in his career. As in Provincetown, there was really no community of photographers in Boston in the 1950s.[8] Jules did exhibit his work during the 1950s and he did encourage the photographer Irene Shwachman early in her career but there was no critical mass of photography in Boston. In the 1950s he was one of the big fishes in a small pond. Things began to change starting in the late 1950s when the Carl Siembab Gallery began to show photography regularly.[9] The Siembab Gallery became a center of the photographic community in Boston and Jules was part of that community. Things really began to heat up in Boston with the appointment of Minor White as an assistant professor at M.I.T. in 1965.[10] The explosion of interest in photography in Boston, especially in the academic world, heralded the movement in the art world toward a new respect for the often ignored and sometimes reviled "step-child" of Art. By the end of the 1960s, photographs were being bought, exhibited, studied and talked about at a high pitch of frequency.

Instead of throwing Jules' career into relief, the spotlight on photography threw him farther back into the shadows. He may have been a part of the military/industrial complex but he was not a part of the new art/academic complex. He did not regularly write about or teach photography, and he did not have disciples to carry his word out into the world. Because of his continuing career and education as a physicist, he did not have the time to publicize his work. While he did continue to exhibit during the 1960s and 70s, including in a group show in 1966 with Minor White, Harry Callahan, Paul Caponigro and others,[11] his work was lost in the flood of new photography and new movements and schools of thought. His photographs would sometimes appear in publications, but never at the size and resolution that would highlight his strength in composition and his dynamic sense of action and movement. As the years went by, photographers like Jules were resigned to the "Family of Man" purgatory, their photographs seen as naively idealistic. Many photographers (Weegee, Robert Frank and Diane Arbus led the parade) cast a cynical eye on their subjects, highlighting the ironic and grotesque. Photographers like Jules Aarons were looked at as throwbacks, and, at the time, it was a fair assessment.

But Jules continued to take photographs, unconcerned with his lack of influence in the new world of photography. Flying under the radar had its advantages. He never felt pressure to do anything new or follow a trend. His style remained remarkably consistent over the course of his career. There is a sense in his photographs of the sovereignty of the subject, the skills of the photographer serving only the need of the image. Not without ego (his ability to pursue excellence in both his chosen careers is proof of that), Jules was able to effectively erase himself from his photographs. From his time in Provincetown, Jules set himself on a path from which he rarely deviated. The interaction with his fellow artists and tutelage under Sid Grossman profoundly strengthened his determination to go his own way. His Provincetown experience added a new dimension to his photography, a new awareness of composition and form. Instincts sharpened, and knowledge gained, Jules Aarons carried Provincetown with him for the rest of his career. He had won the right to be judged on his own merits, his photographs his best advocates. He may not have been an artist when he came to Provincetown, but he was an artist when he left.

AARON SCHMIDT
*Print Department Photo Collection*

18

# NOTES

1. BPL interview (see first footnote in John Stomberg's essay, "Provincetown–1949"). Information on Jules Aarons' experience in Provincetown in this essay derived from the BPL interview and various discussions and email exchanges between Jules and myself from 1999 to 2002.

2. Jules Aarons, *Into the Streets, 1947–1976, Photographs of Boston by Jules Aarons* (Boston Public Library, 1999), 12.

3. Dorothy Gees Seckler, "History of the Provincetown Art Colony," in Ronald A. Kuchta, ed., *Provincetown Painters* (Syracuse, NY: Everson Museum of Art, 1977).

4. BPL Interview.

5. BPL Interview.

6. Aarons, 8.

7. Hans Hofmann, *The Search for the Real and Other Essays* (Andover, MA: Addison Gallery of American Art, 1948), 7–10.

8. Kim Sichel, "Science and Mysticism," in *Photography in Boston: 1955–1985*, ed. by Rachel Rosenfield Lafo and Gillian Nagler (Lincoln, MA: DeCordova Museum, 2000), 23–25. This catalogue based on a retrospective exhibit at the DeCordova Museum provides an excellent general history of Boston photography in the post-war era, with essays by Kim Sichel, Rachel Lafo and A. D. Coleman. All of the information on the Boston photography scene in this essay is from this valuable source.

9. Sichel, 23.

10. Sichel, 16.

11. *Photography in Boston: 1955–1985*, ed. by Rachel Rosenfield Lafo and Gillian Nagler (Lincoln, MA: DeCordova Museum, 2000), 157.

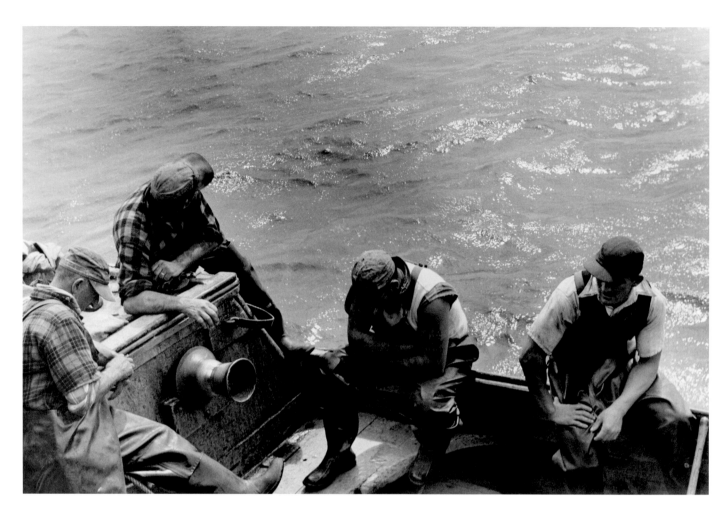

*A Brief Pause in the Operations*

# P-TOWN: A REMINISCENCE BY JULES AARONS

THE PHYSICAL SCENE . . . Provincetown was built on the bay side of the loop that is the tip of Cape Cod. The town was narrow on the bay side with two parallel streets, Bradford and Commercial. One could walk it easily.

There was a lot of excitement in the summer . . . the sea and the boats and the pleasant evenings and the sand dunes and the swimming. It had a lot going for it in the summer. The fish in 1949 were plentiful. The local fishermen went out, not too far, and were able to net tuna, lots of tuna, and other fish to be gathered up easily in nets. They landed some in Provincetown by pulling into the pier, unloading them in a large metal container and pulling the container on tracks from the beach into a shed. In the shed they were iced and partially processed. And you could buy tuna in town . . . 19 cents a pound and certainly very fresh. I went out with the fishermen to try to photograph them without their paying attention to me. They were hospitable.

There were trinket shops, art galleries, artisan shops, and of course food shops as well as the Provincetown Art Association and the Provincetown Museum (the last courtesy of Walter Chrysler). Openings were on Friday night with artists, collectors, and everyone else. There were lectures in 1949 and many artists attended. Provincetown always had schools of art ranging from students depicting the boats and docks to formal schools such as Hans Hofmann's. And there was an interchange of ideas at the galleries, at homes, and chance meetings in the street.

The dominant school was that of Hans Hofmann; there was admiration for the master. In the case of Hofmann his words set the students along new paths. New York collectors reigned and some artists and their families pursued them. The artists were there . . . from New York, Boston, wherever. Photographers were there too. Sid Grossman ran a one-man school. Lisette Model stayed for the summer and had students some years. One word to describe the relationships among people . . . interactive . . . artists spoke to one another . . . they mingled with cartoonists such as Misha Richter . . . with purveyors of new looks in clothing (Ellie Gibran), with photographers. What happened when one artist showed his work to another? Disdain if it wasn't his or her approach . . . admiration? A thought that they should change somewhat . . . at any rate communication.

I was there with my wife and son in 1949 and later with both of my sons. One year we rented a small cottage one block from the waterfront with a single room; I went back to Boston to my technical position at the crack of dawn on Monday morning after coming out to Provincetown Friday afternoon. We dug into the Provincetown scene by taking two weeks of vacation and spending it all in P-Town. The first cottage we rented was next to the house that Ruth Cobb and Lawrence Kupferman, our very good friends, rented for the summer. When the Kupfermans decided not to come back in 1950 we took the large house along with our friends, Ruth and George Freedman and their children.

There were groupings . . . ours was the Boston artist set which included Kahlil Gibran and his wife Ellie (who ran Paraphernalia Clothing),

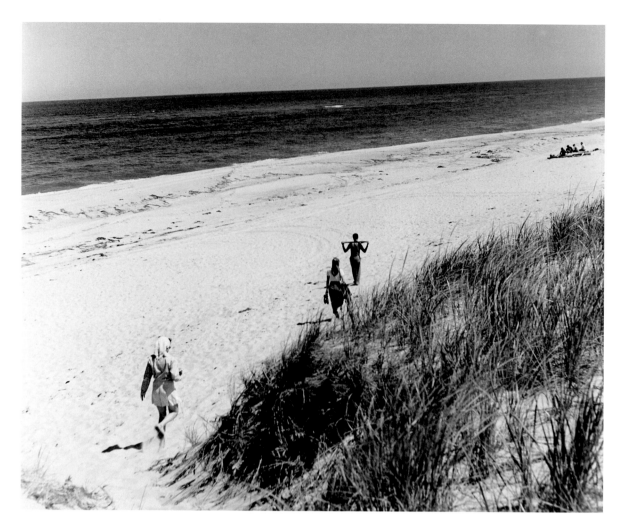

*The Beach and the Dunes*

Giglio Dante and his friend who ran a dance school, Ken Campbell, Laurie Kupferman, Ruth Cobb plus visitors. I did use the time in Province-town to make portraits of my friends. For the most part these were of fellow Boston artists but there were others.

I took the opportunity of going from self-taught to obtaining the sharp eye and tongue of Sid Grossman. He had words not only for the photographic values but of your intentions in designing the photograph. He was a tough critic and it helped enormously to go beyond self-criti-cism. Since I was in Boston during the week I was able to make more prints so that even the rela-tively few and very brief half-hour sessions could be used in a progressive way.

These photographs present a document of Provincetown in the years that I spent there. I enjoyed the experience tremendously. It is a very personal view that includes what I saw: the beach, the fishermen, the dunes, the art classes, the lec-tures, the Blessing of the Fleet, the local year-round group, and some of the people I knew . . .

# PROVINCETOWN, VILLAGE AND COLONY

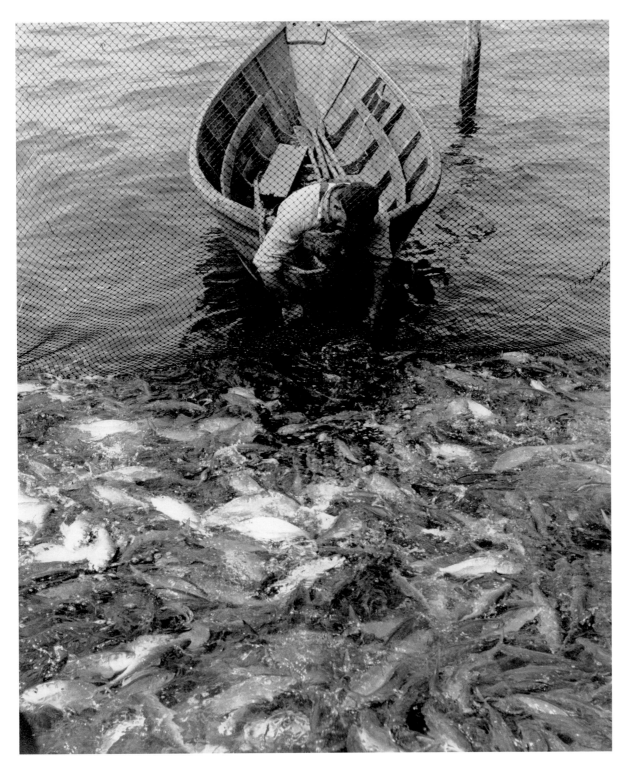

*Netting the Catch*

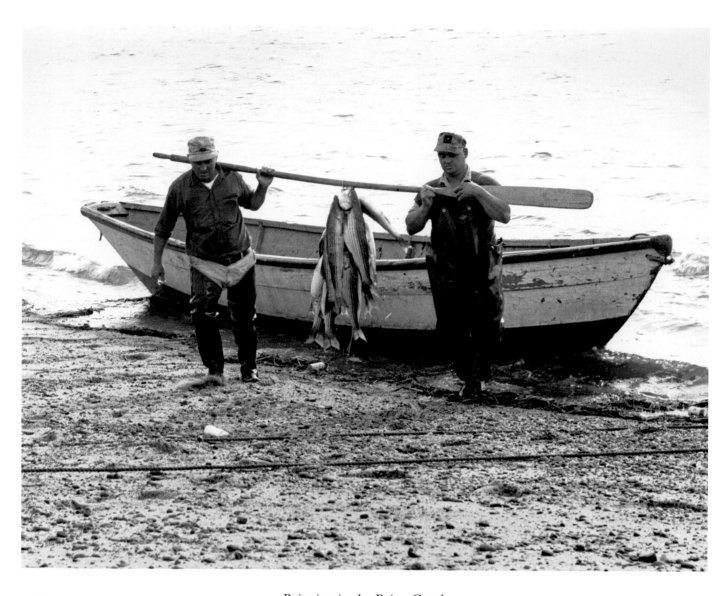

*Bringing in the Prize Catch*

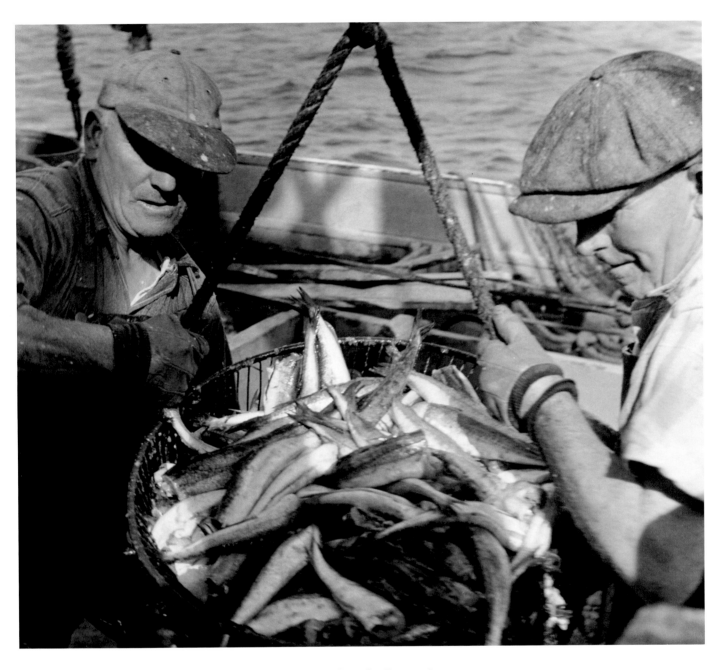

*Off-Loading for Processing*

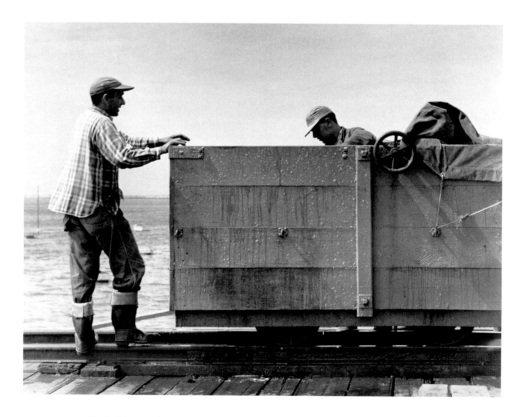

*Fish Train for Hauling Catch to End of Pier for Processing*

26

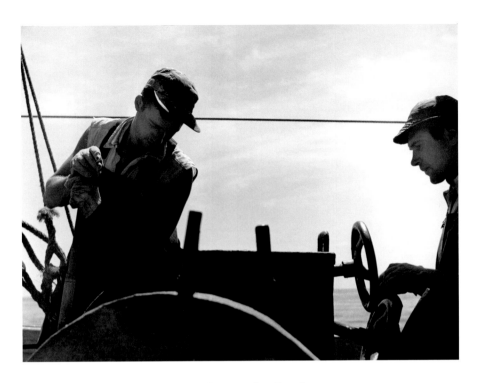

*Hauling in the Catch*

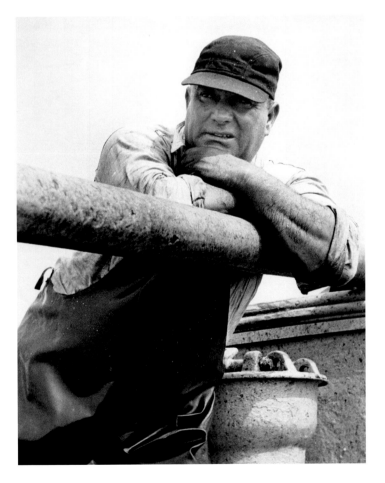

*A Moment of Rest on the Outgoing Boat*

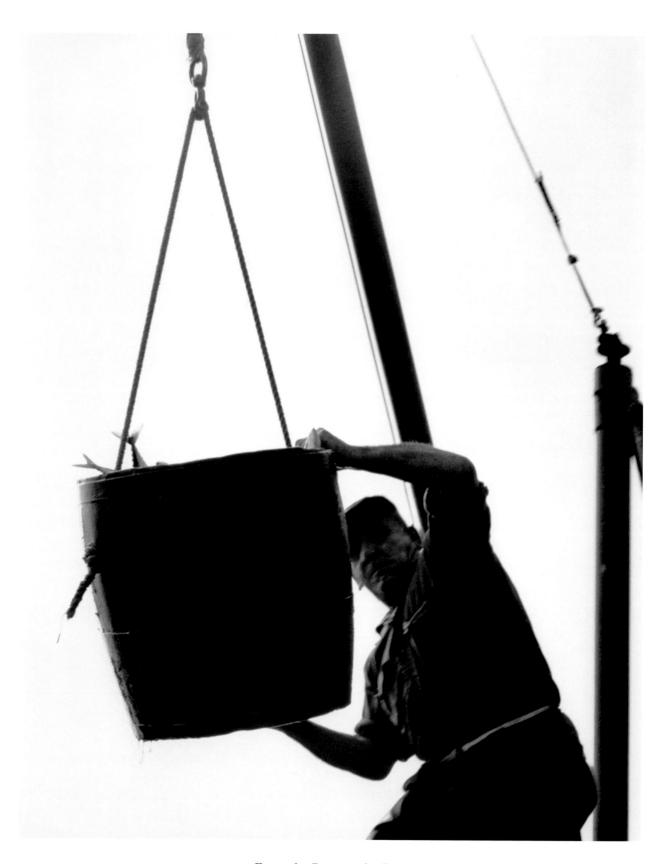

*From the Boat to the Pier*

28

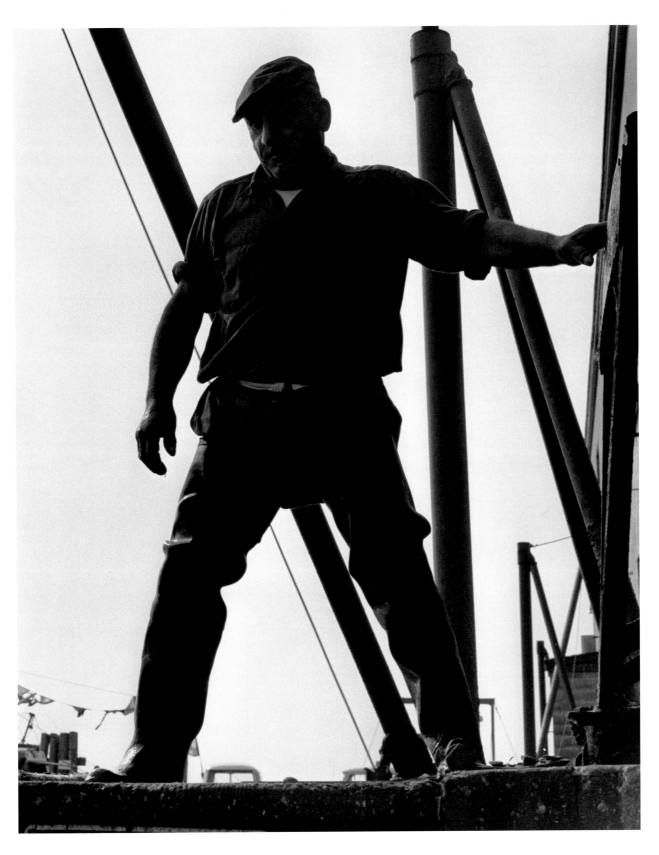

*From the Boat to the Pier*

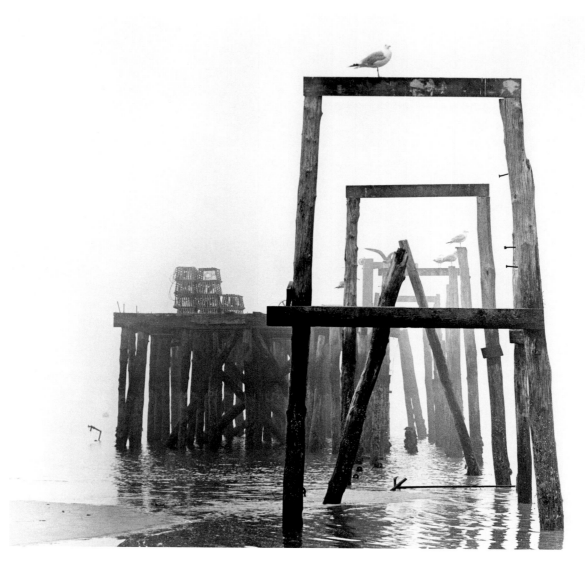

*Abandoned Pier from More Active Days, 1965*

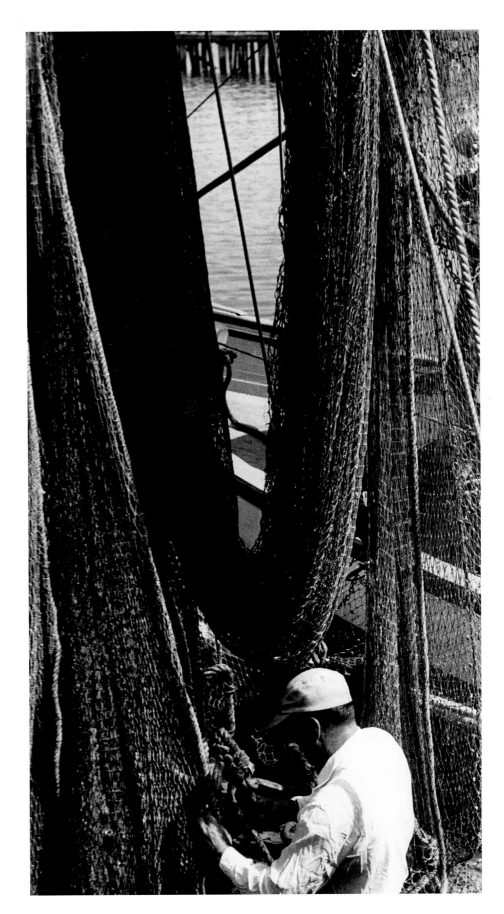

*Drying the Nets*

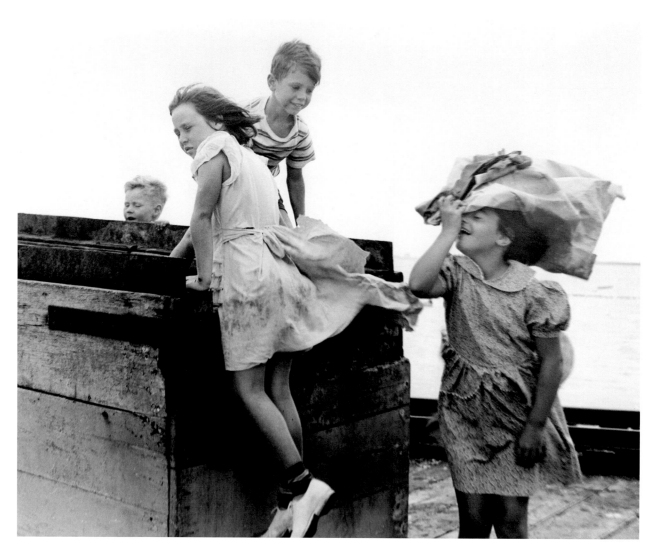

*Playing on the Pier*

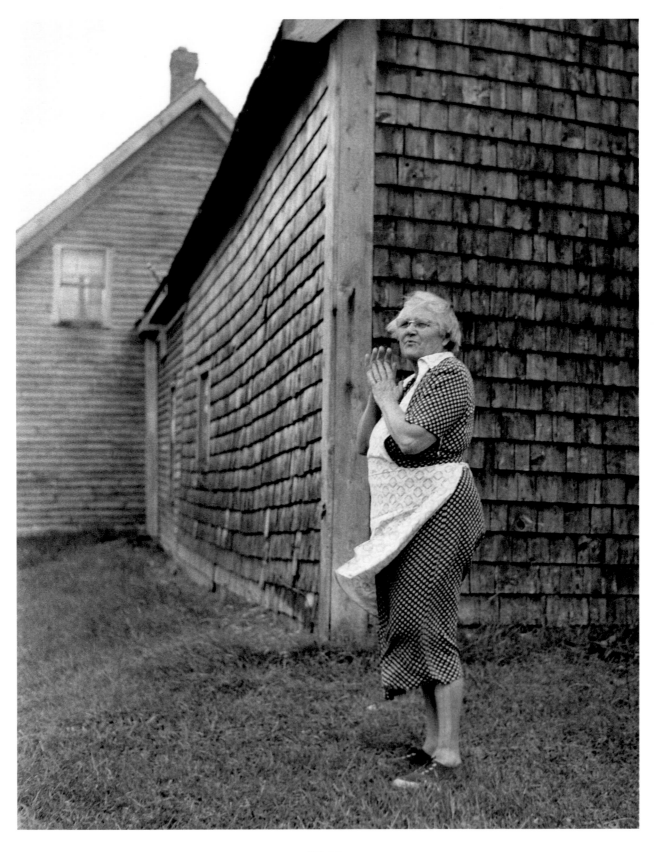

*Waiting*

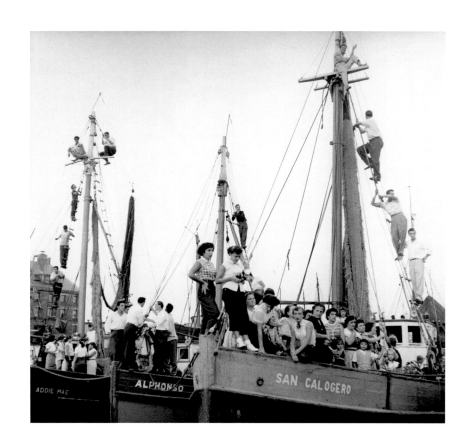

*Blessing of the Fleet, 1965*

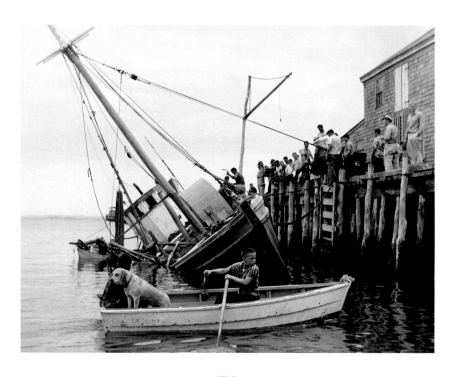

*Tilt*

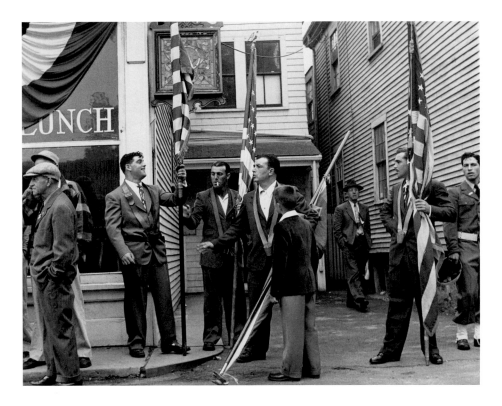

*July 4th, Before the Procession*

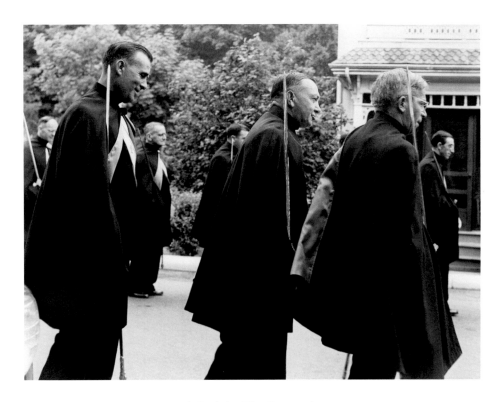

*July 4th, The Procession*

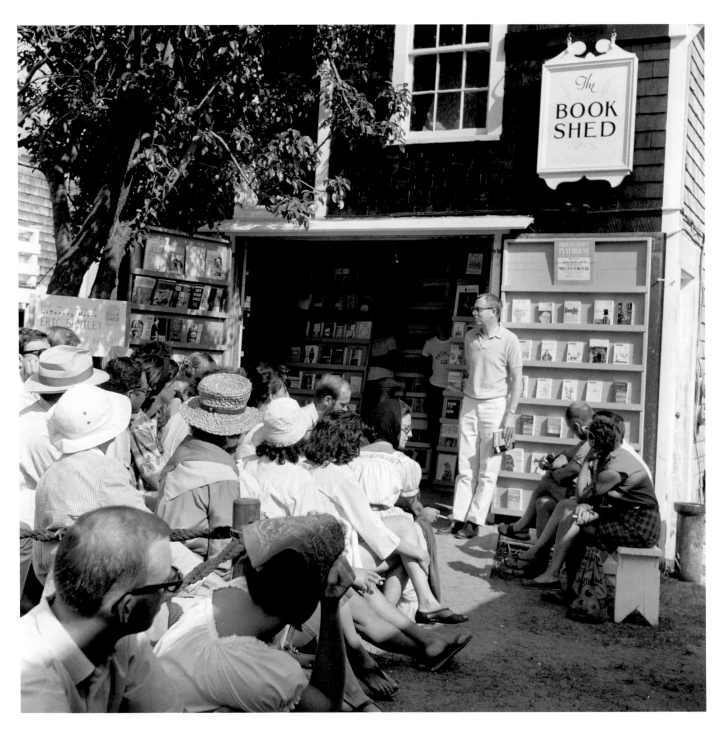

*Books and Arts and Tourists*

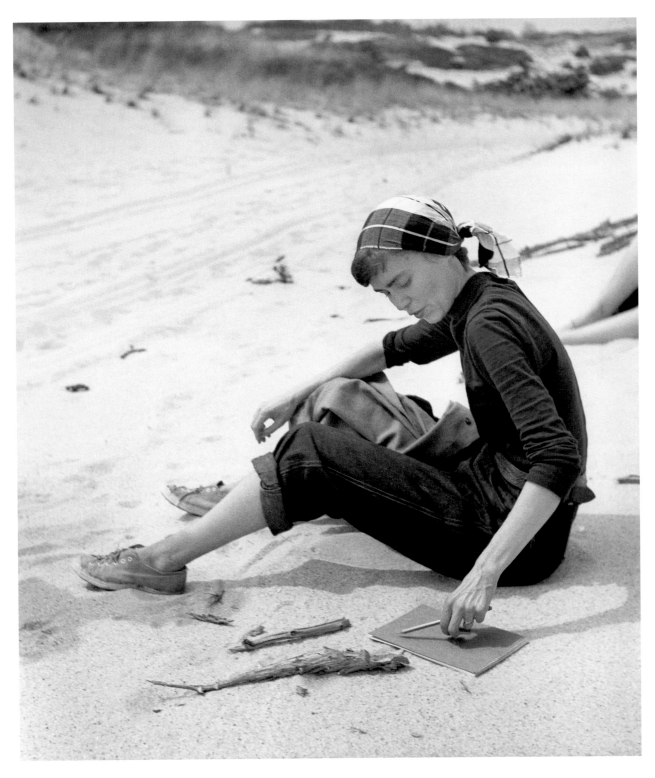

*Ellie Gibran Sketching in the Dunes*

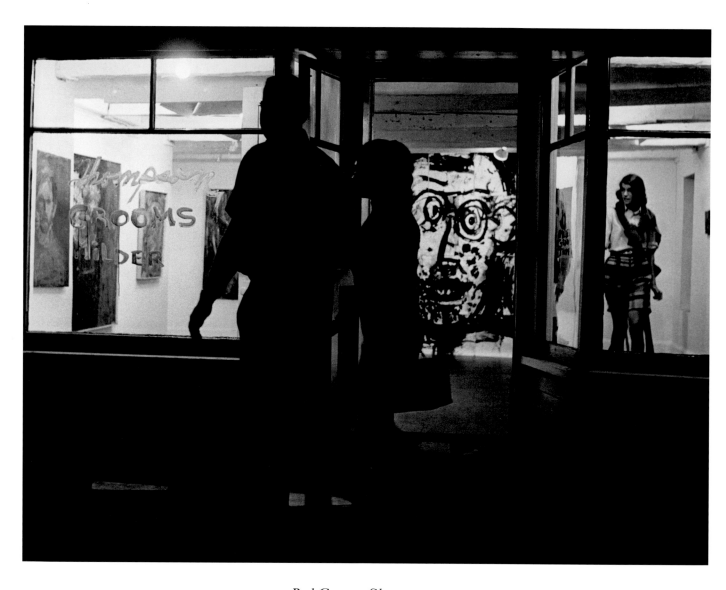

*Red Grooms Show, 1959*

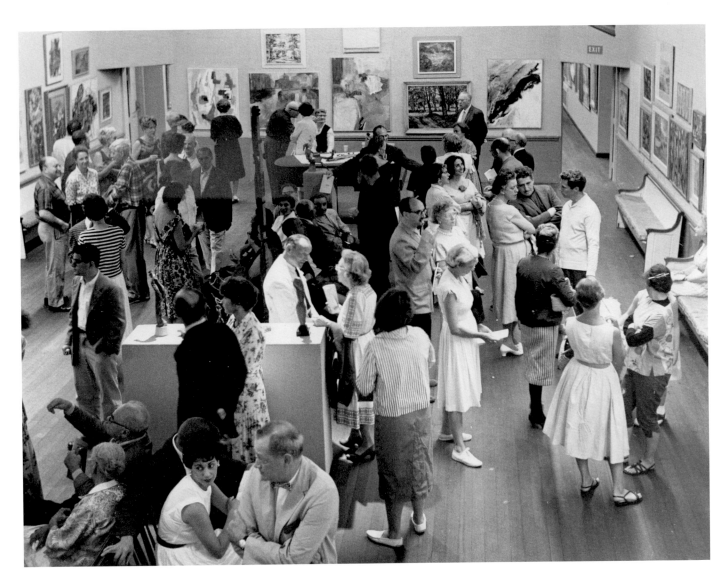

*Provincetown Art Association Opening*

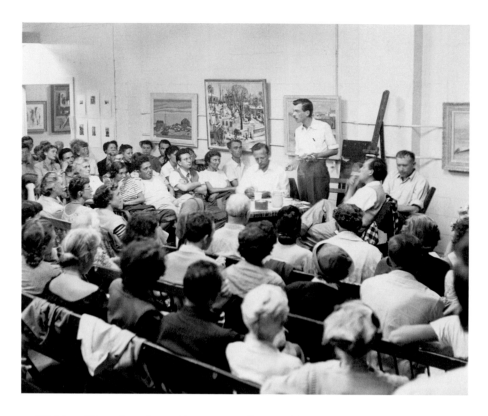

*Weldon Kees Opening a Lecture in Forum 49, Gyorgy Kepes in Profile*

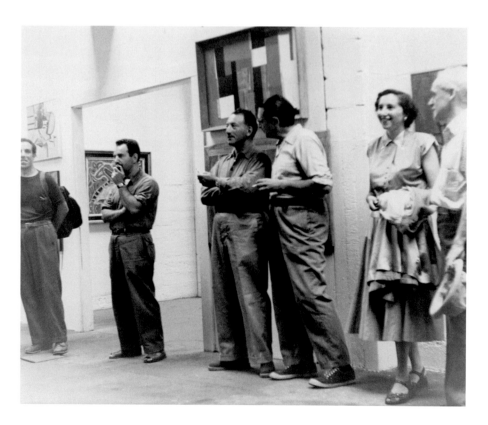

*Left to Right: Boris Margo, Leo Manso, Adolph Gottlieb, Lawrence Kupferman, Ruth Cobb and Fritz Pfeiffer*

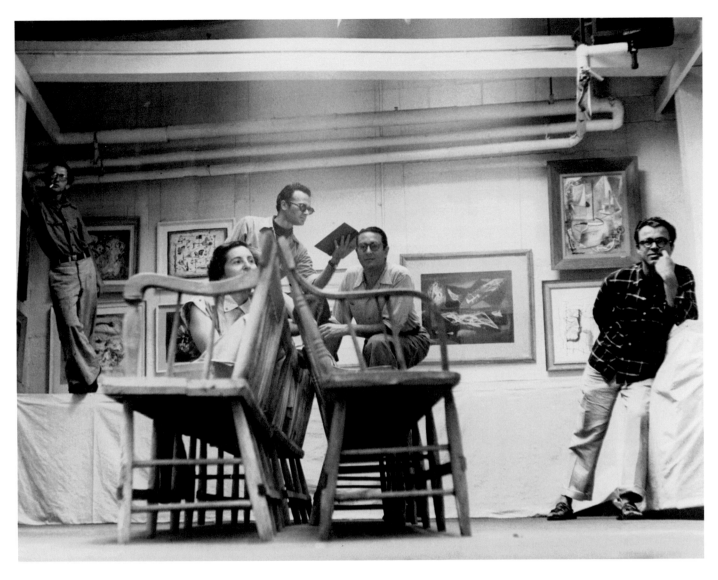

*Boston Artists in Provincetown Studio, Left to Right, Kahlil Gibran, Ruth Cobb, Giglio Dante (with book), Lawrence Kupferman and Ken Campbell*

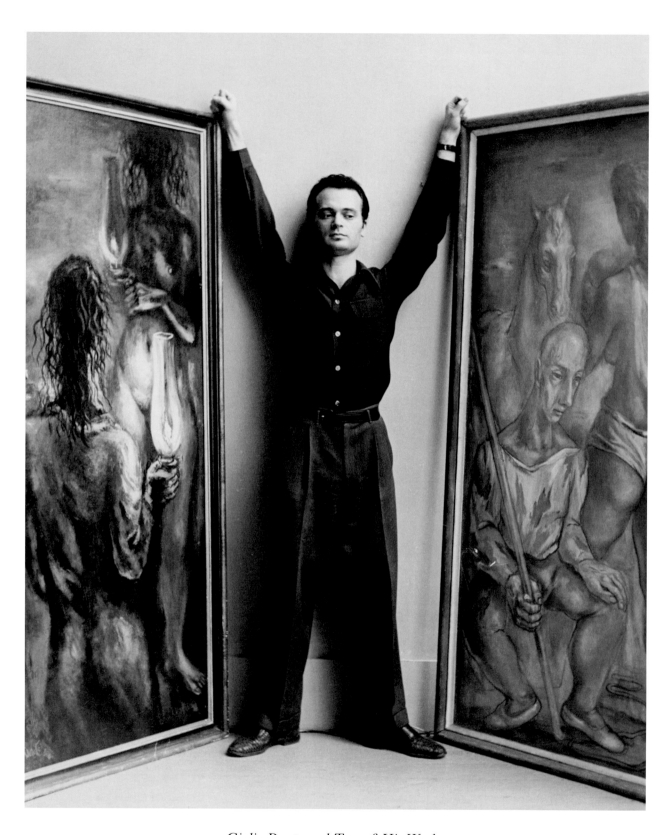

*Giglio Dante and Two of His Works*

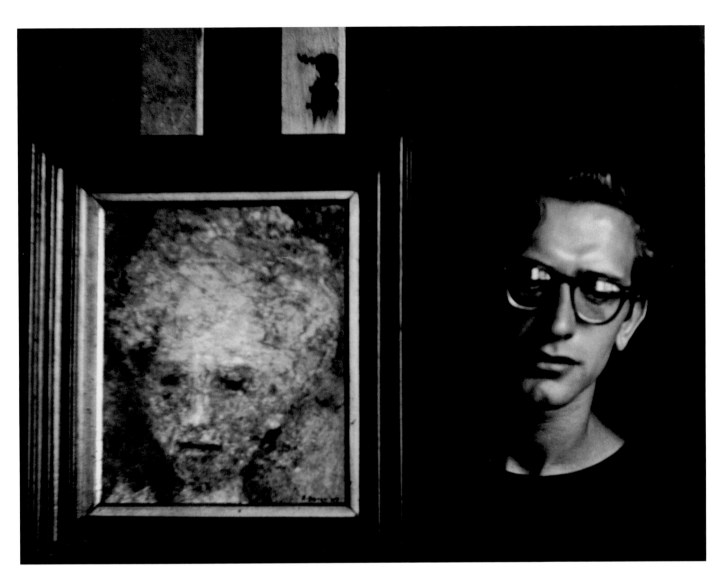

*Kahlil Gibran and His Study*

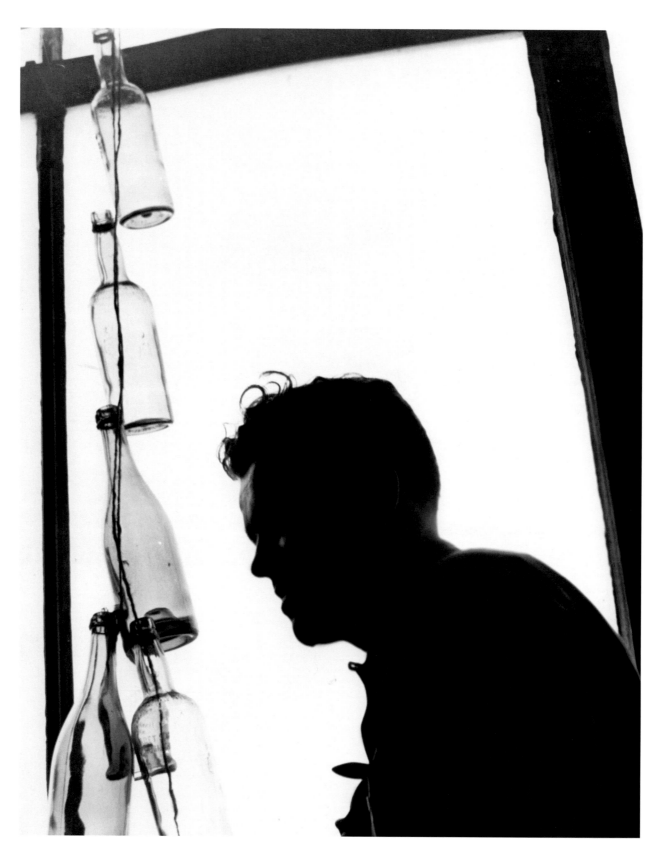

*Ken Campbell in His Studio*

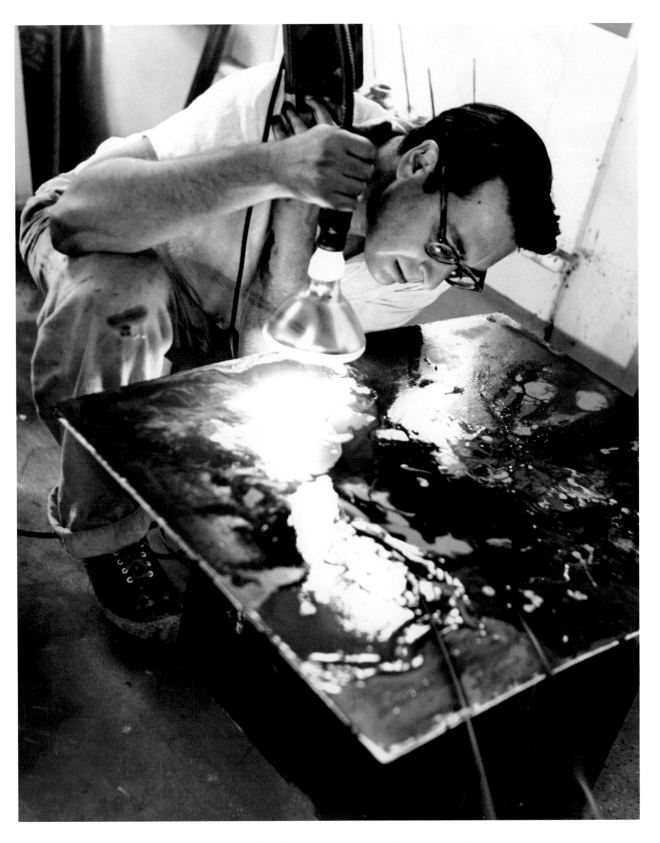

*Lawrence Kupferman, Flow and Heat Method*